and precious luther an act of goodness

od shows th___ morning shows

ndino wisdom ___ nder socrates the

le say you cannot do it's good to be queen each

ve to be foremost in good deeds benjamin

ek proverb our first teacher is our own heart

ok up is joy confucius the future belongs to

eams eleanor roosevelt where there is love there

u are seeking is in yourself little minds achieve

k keep company with those who make

t possession benjamin franklin we shall light a

ut out anonymous love is the river of life in

dream to create the future victor hugo a life

overb grow old along with me the best is

were as long as twenty days are yo

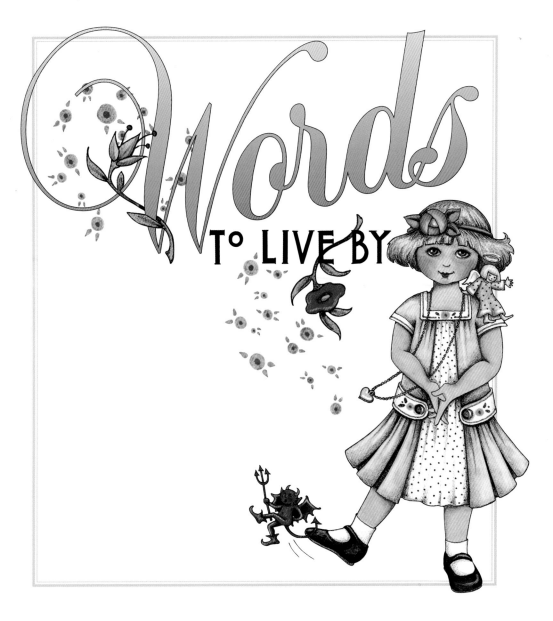

Words

TO LIVE BY

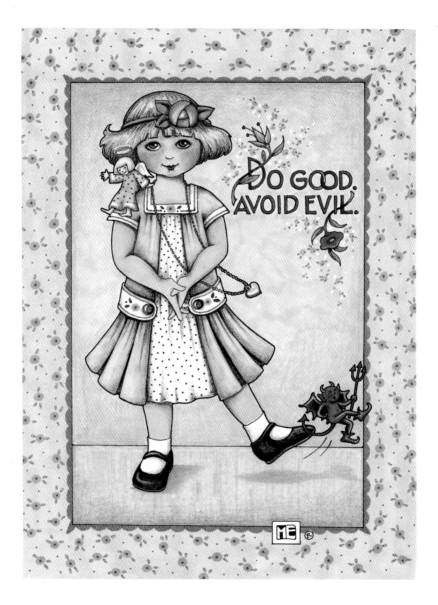

Words

TO LIVE BY

illustrated by Mary Engelbreit

**Andrews McMeel
Publishing**

Kansas City

www.andrewsmcmeel.com
www.maryengelbreit.com

 is a registered trademark of Mary Engelbreit Enterprises, Inc.

Words to live by / illustrated by Mary Engelbreit.
 p. cm.
 ISBN 0-7407-0028-6
 1. Conduct of life Quotations, maxims, etc. I. Engelbreit, Mary.
PN6084.C556W67 1999
082--dc21 99-37116
 CIP

Edited by Jean Lowe
Design by Stephanie R. Farley

ATTENTION: SCHOOLS AND BUSINESSES
Andrews McMeel books are available at quantity discounts with bulk purchase for educa-
tional, business, or sales promotional use. For information, please write to: Special Sales
Department, Andrews McMeel Publishing, 4520 Main Street, Kansas City, Missouri 64111.

Contents

A few Words...

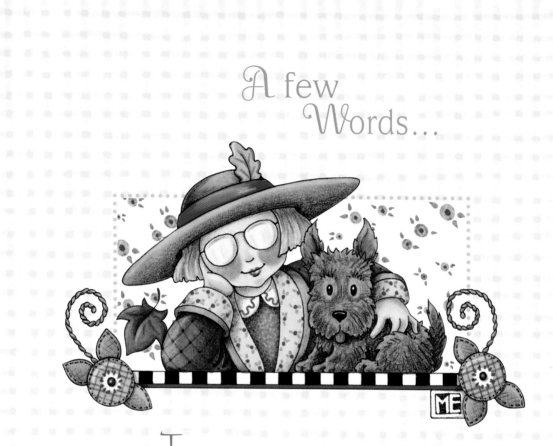

The more I think about it, the more I realize there is nothing more artistic than to love others.

—Vincent van Gogh

...from
Mary Engelbreit

In *Words to Live By,* I have put together a collection of drawings that are based on many of my favorite quotations, proverbs, and bits of wisdom. So many of my greeting cards, calendars and drawings illustrate the thoughts and ideas of other people as well as my own.

I grew up reading and still have a huge appetite for literature. Many of my most well known sayings have come from some of my favorite authors. You will find within these pages quotations from all kinds of authors, and the best part is that we all can interpret them in our own way. Graham Greene's comment "there is always one moment in childhood when the door opens and lets the future in," was especially meaningful to me because I wanted to be an artist at a very early age.

I also hear wonderful words to illustrate all around me everyday. Things my children, my friends and their children say often wind up as card images or a calendar page, and I conclude this book with a few of these pieces of wit or wisdom that I have gathered. For example, when I was a girl, my neighbor's slip of the tongue developed into one of my better known sayings, "Life Is Just a Chair of Bowlies." I used this spoonerism to launch my greeting card business twenty years ago. My son, Will, gave me "A Little Peace of Quiet," and my son, Evan, inspired "A Man Among Men," which are, for obvious reasons, two of my favorite drawings.

I hope the readers of this work enjoy these "Words to Live By" as much as I have enjoyed illustrating them.

Mary

there is nothing like a dream
create the future victor hugo love cor
forteth like sunshine after rain will
shakespeare to a young heart everythin
is fun charles dickens childhood shows th
man, as mor s the day j
milton heaven is feet as we
as over ou henry david thor
friendship is love without wings
byron love and you shall be loved ra
waldo emerson grow old along with me th
best is yet to be browning never lose
chance of saying a kind word will
makepeace thackeray sweet childish day
that were as long as twenty days

...from great writers

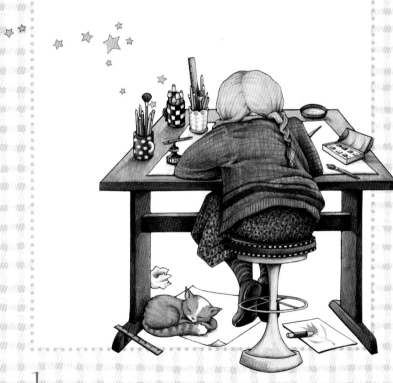

It is art that makes life, makes interest, makes importance, and I know of no substitute for the force and beauty of its process.
–Henry James

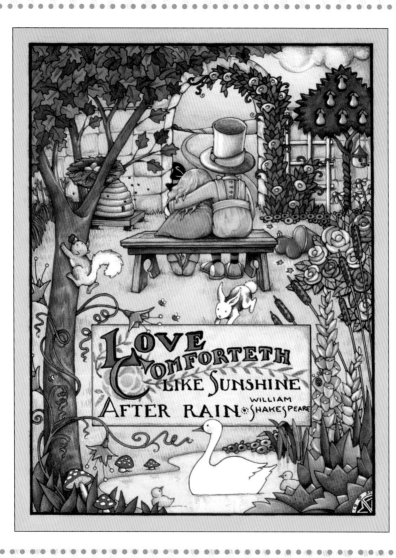

LOVE COMFORTETH LIKE SUNSHINE AFTER RAIN
WILLIAM SHAKESPEARE

Love and you shall be loved.
 -Ralph Waldo Emerson

Love is a great beautifier.
 -Louisa May Alcott

Love conquers all.
 -Virgil

Where there is great love,
 there are always miracles.
 -Willa Cather

But there's nothing
half so sweet in life
as love's young dream.
–Thomas Moore

Heaven is under our feet
as well as over our heads.
–Henry David Thoreau

To a young heart everything is fun.
–Charles Dickens

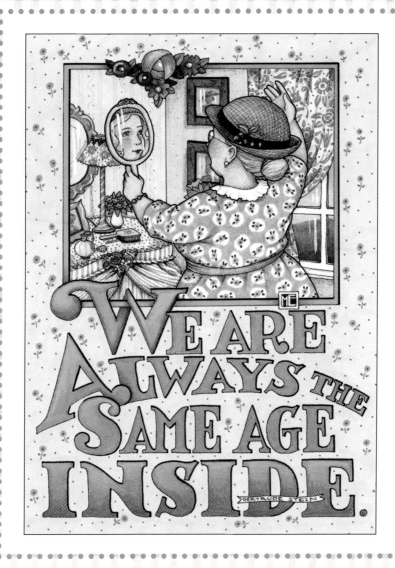

WE ARE ALWAYS THE SAME AGE INSIDE.

GERTRUDE STEIN

\mathcal{S}weet childish days,
that were as long
as twenty days are now.

–Wordsworth

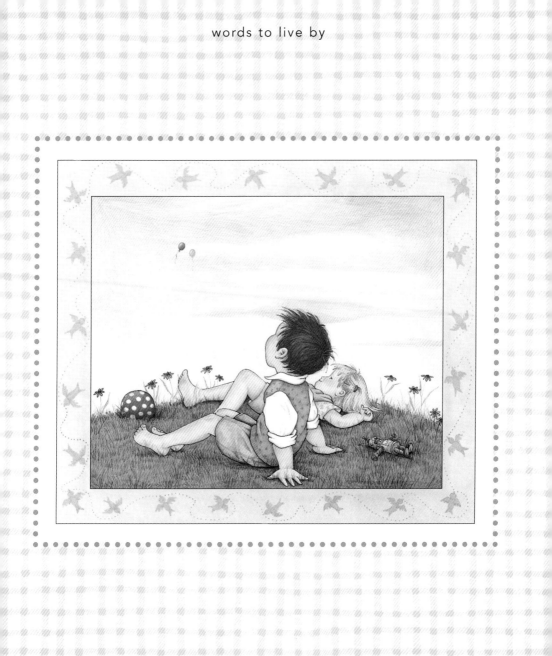

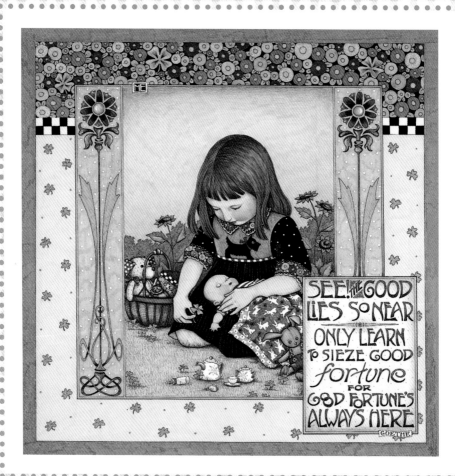

SEE! the GOOD
LIES SO NEAR
ONLY LEARN
To SIEZE GOOD
fortune
FOR
GOD FORTUNE'S
ALWAYS HERE
GOETHE

Never lose a chance
of saying a kind word.
–William Makepeace Thackeray

We ought, everyday,
to hear a song,
read a fine poem,
and, if possible,
to speak a few reasonable words.
–Goethe

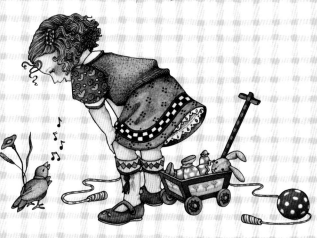

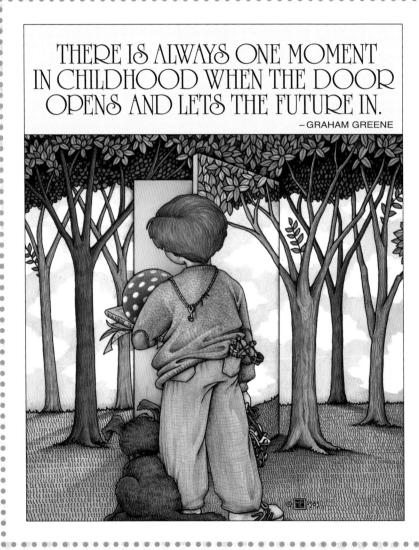

THERE IS ALWAYS ONE MOMENT IN CHILDHOOD WHEN THE DOOR OPENS AND LETS THE FUTURE IN.

– GRAHAM GREENE

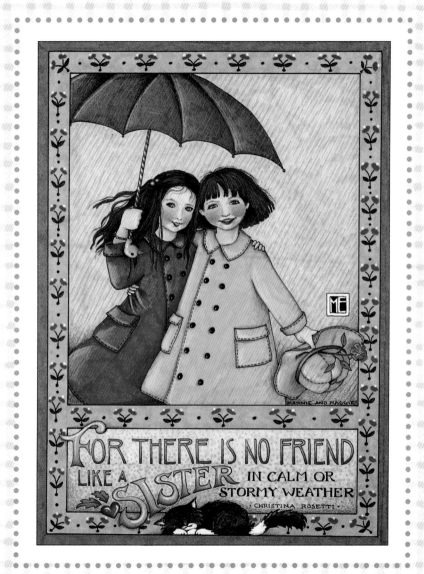

FOR THERE IS NO FRIEND
LIKE A SISTER IN CALM OR
STORMY WEATHER
· CHRISTINA ROSETTI ·

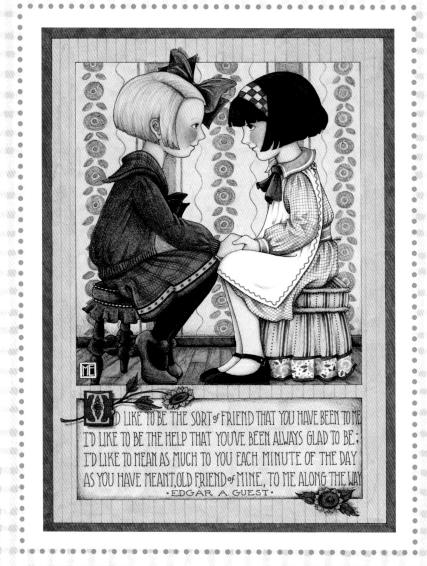

I'D LIKE TO BE THE SORT OF FRIEND THAT YOU HAVE BEEN TO ME
I'D LIKE TO BE THE HELP THAT YOU'VE BEEN ALWAYS GLAD TO BE;
I'D LIKE TO MEAN AS MUCH TO YOU EACH MINUTE OF THE DAY
AS YOU HAVE MEANT, OLD FRIEND OF MINE, TO ME ALONG THE WAY
· EDGAR A. GUEST ·

My friends are my estate.
—Emily Dickinson

Friendship is love without wings.

—Lord Byron

flowers are lovely;
love is flower-like;
Friendship is a sheltering tree.
—Coleridge

21

Summer afternoon,
summer afternoon;
to me those have always been
the two most beautiful words
in the english language.
—Henry James

A good laugh is

sunshine

in a house.

–William Makepeace
Thackeray

Keep true to the
dreams of your youth.
–Johann Friedrich von Schiller

There is nothing like a dream
to create the future.
–Victor Hugo

The best way to make children good
is to make them happy.
–Oscar Wilde

Youth comes but once in a lifetime.

–Henry Wadsworth Longfellow

25

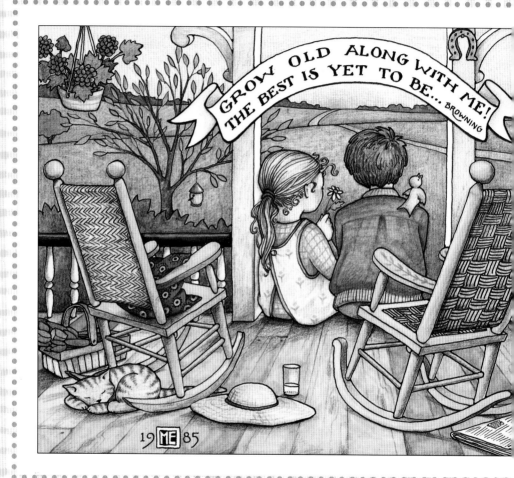

In three words
I can sum up everything I've learned
about life: It goes on.

—Robert Frost

an act of goodness surpasses a thousand prayers *sa 'di* do all things with love *og mandino* the heart of the giver makes the gift dear and precious *luther* each has a direction to which he turns so strive to be foremost in good deeds *benjamin disraeli* where there is love there is life *gandhi* don't forget to love yourself *sören kierkegaard* love is the river of life in the world *henry ward beecher* we shall light a candle of understanding that shall not be put out *anonymous* make of yourself a light *buddha* how good and how pleasant it is that brothers sit together

...from great spiritual guides

We shall light a candle of understanding in our hearts which shall not be put out.

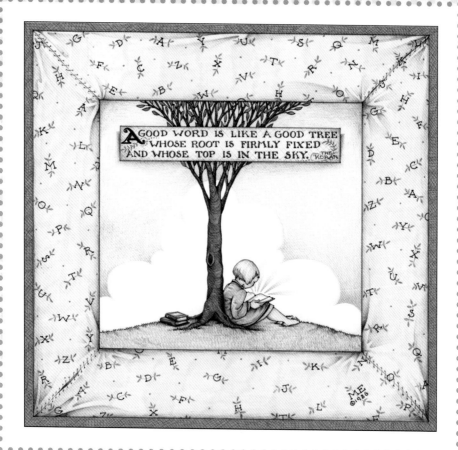

A GOOD WORD IS LIKE A GOOD TREE WHOSE ROOT IS FIRMLY FIXED AND WHOSE TOP IS IN THE SKY. —THE KORAN

*O*ur first teacher is our own heart.

–Cheyenne

*B*e kind to everything that lives.

–Omaha

*A*n act of goodness
surpasses
a thousand
prayers.

–Sa'di

*D*o all things with love.

–Og Mandino

Where there is love
there is life.
—Mahatma Gandhi

Love is the river of life
in the world.
—Henry Ward Beecher

TRUE ♥ LOVE

Don't forget to love yourself.
—Sören Kierkegaard

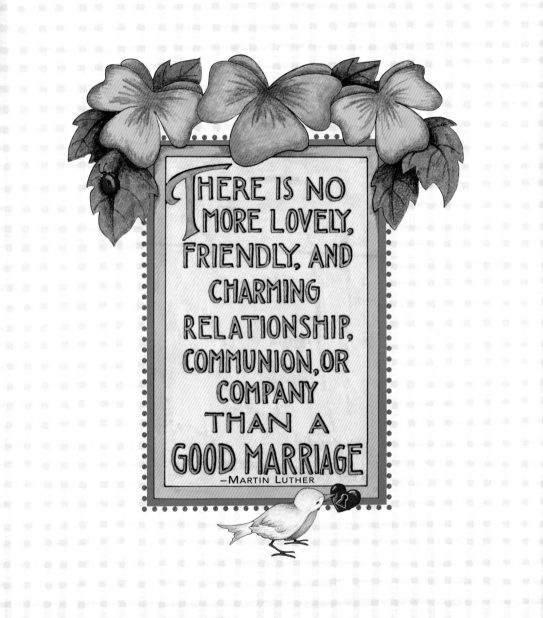

THERE IS NO MORE LOVELY, FRIENDLY, AND CHARMING RELATIONSHIP, COMMUNION, OR COMPANY THAN A GOOD MARRIAGE

—MARTIN LUTHER

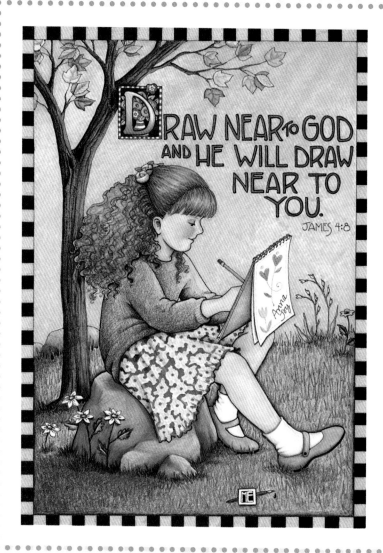

There is no friendship, no love,
　　like that of the parent
　for the child.
　　　　　　–Henry Ward Beecher

How good and how pleasant
　　　　　it is that brothers sit together.
　　　　　　　　　–Psalm 133:1

A mother's heart
　　　is a child's classroom.

　　　–Henry Ward Beecher

MAKE OF YOURSELF A LIGHT. BUDDHA

Each has a direction to which he turns;
so strive to be foremost in good deeds.
—the Koran

The heart of the giver
makes the gift dear and precious.
—Luther

Life is both giving and receiving.
—Mohawk

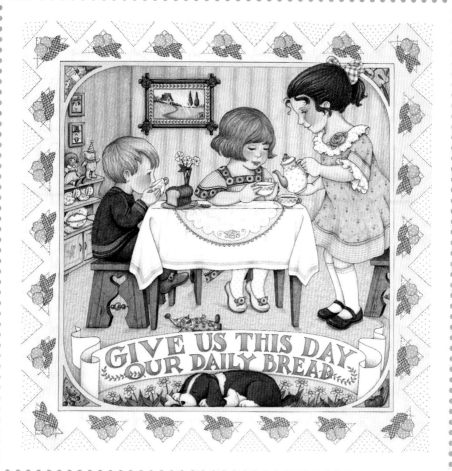

GIVE US THIS DAY OUR DAILY BREAD

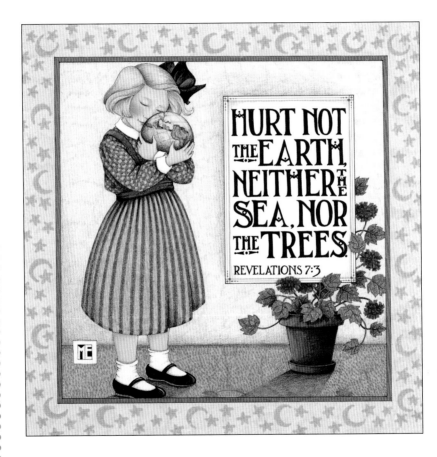

HURT NOT THE EARTH, NEITHER THE SEA, NOR THE TREES.

REVELATIONS 7:3

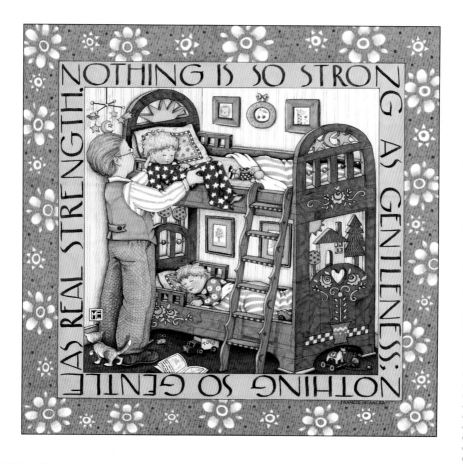

only from the heart can you touch the sky rumi all great things are simple sir winston churchill in all things of nature there is something of the marvelous aristotle no act of kindness, no matter how small, is wasted aesop to look up is joy con... ...on, there strength aesop w... ...ns in wonder socrates we make a living by what w... get, but we make a life by what w... give sir winston churchill a true friend is th... best possession benjamin franklin our li... is what our thoughts make it mar... aurelius the future belongs to those wh... believe in the beauty of their drea...

...from great thinkers

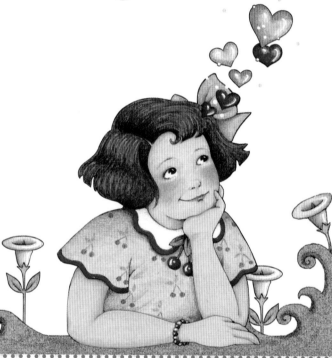

N urture your mind with great thoughts.
– Benjamin Disraeli

WHEN YOU REACH THE END OF YOUR ROPE, TIE A KNOT IN IT AND HANG ON.

Thomas Jefferson

The highest form of bliss
is living with
a certain degree of folly.
—Erasmus

To live is to function.
That is all there is in living.
—Oliver Wendell Holmes

Remember that
very little is needed
to make a happy life.
—Marcus Aurelius

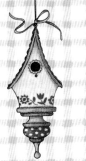

The best thing about the future
is that it comes only
one day at a time.
—Abraham Lincoln

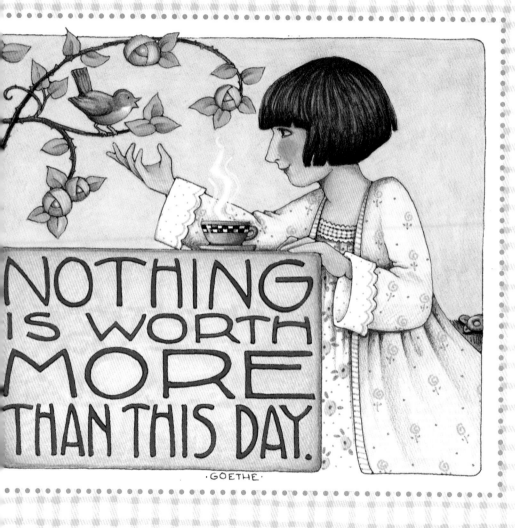

NOTHING IS WORTH MORE THAN THIS DAY.

·GOETHE·

A short saying
 often contains much wisdom.
 –Sophocles

Most folks
 are about as happy
 as they make up
 their minds to be.
 –Abraham Lincoln

Our life is what
 our thoughts make it.

 –Marcus Aurelius

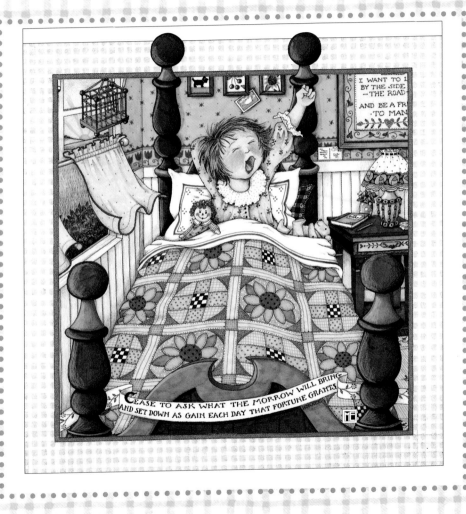

I WANT TO L
BY THE SIDE
THE ROAD

AND BE A FR
TO MAN

CEASE TO ASK WHAT THE MORROW WILL BRING
AND SET DOWN AS GAIN EACH DAY THAT FORTUNE GRANTS

The happiest moments of my life
have been the few which I have passed at home
in the bosom of my family.
—Thomas Jefferson

Where we love is home.
Home that our feet may leave
but not our hearts.
—Oliver Wendell Holmes

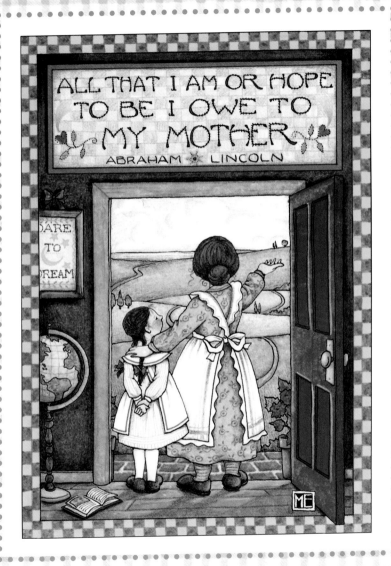

In union,
 there is strength.
 —Aesop

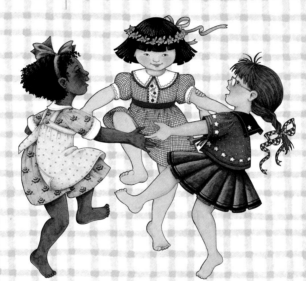

A true friend is the best possession.
 —Benjamin Franklin

Friendship is the only cement
 that will ever hold the world together.
 —Woodrow Wilson

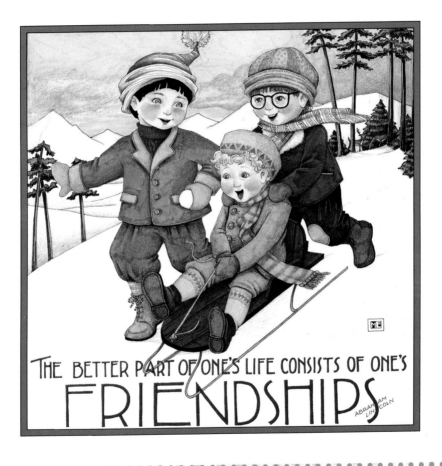

THE BETTER PART OF ONE'S LIFE CONSISTS OF ONE'S FRIENDSHIPS

ABRAHAM LINCOLN

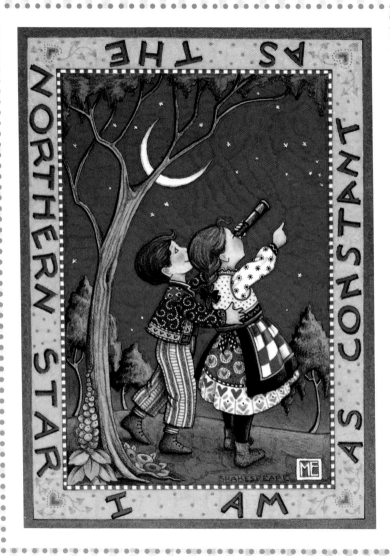

The future belongs to those
who believe in the beauty
of their dreams.
—Eleanor Roosevelt

To look up is joy.
—Confucius

Only from the heart
can you touch the sky.
—Rumi

Wisdom begins in wonder.
—Socrates

No act of kindness,
no matter how small, is ever wasted.
—Aesop

All the great things
are simple.
—Sir Winston Churchill

In all things of nature there
is something of the marvelous.
—Aristotle

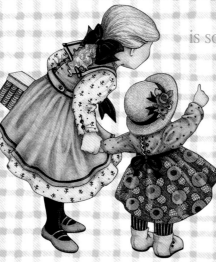

We make a living
by what we get,
but we make a life
by what we give.
—Sir Winston Churchill

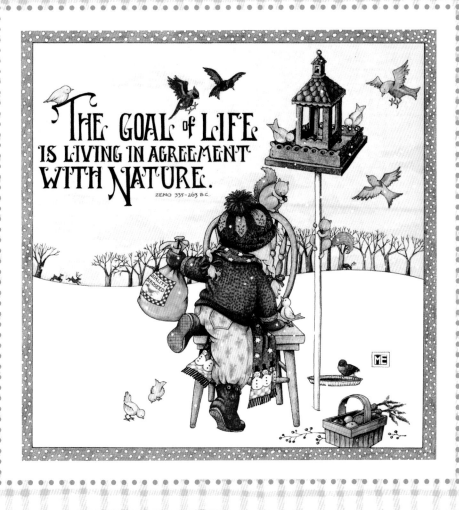

THE GOAL of LIFE IS LIVING IN AGREEMENT WITH NATURE.

ZENO 335-263 B.C.

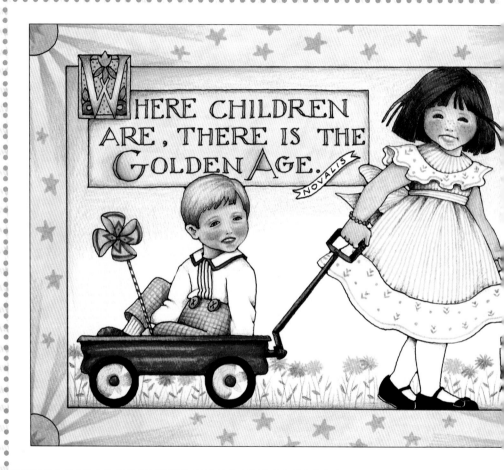

WHERE CHILDREN ARE, THERE IS THE GOLDEN AGE.
—NOVALIS

Seek the wisdom
of the ages,
but look at the world
through the eyes of a child.
—Anonymous

happiness is made to be shared *proverb* bricks and mortar make a house but the laughter of children makes home *irish proverb* who takes the child by the hand takes the mother by the heart *danish proverb* a child is born, there is a grandmother when there is room in the heart there is room in the house *danish proverb* keep company with those who make you better *english saying* the heart that loves is always young *greek proverb* a life without a friend is a life without sun *french proverb* we have not inherited the earth from our fathers we are borrowing it from

...from word of mouth

Words are the voice of the heart.
—Confucius

To believe **everything** is too much,
to believe **nothing**
is not enough.
—German proverb

It is by believing
in roses
that one brings
them to bloom.
—French proverb

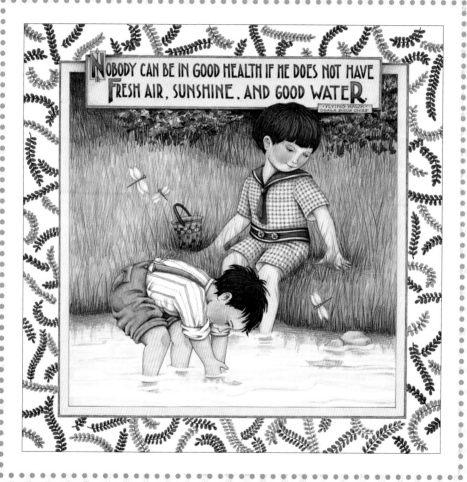

Bricks and mortar make a house
but the laughter of children
makes a home.

—Irish proverb

When there is
room in the heart,
there is room in the house.

—Danish proverb

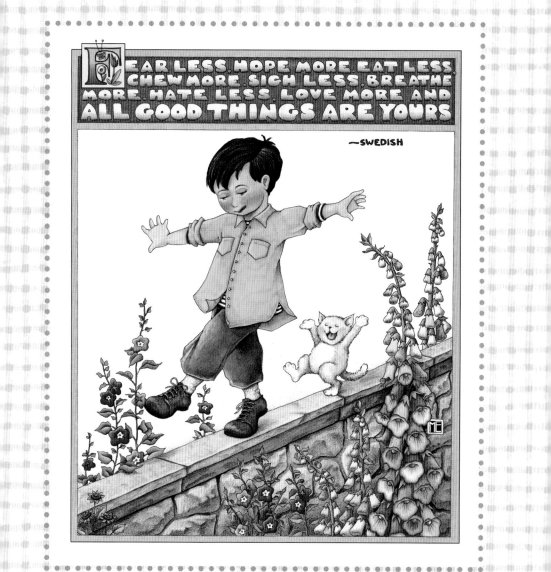

FEAR LESS, HOPE MORE, EAT LESS, CHEW MORE, SIGH LESS, BREATHE MORE, HATE LESS, LOVE MORE AND ALL GOOD THINGS ARE YOURS

—SWEDISH

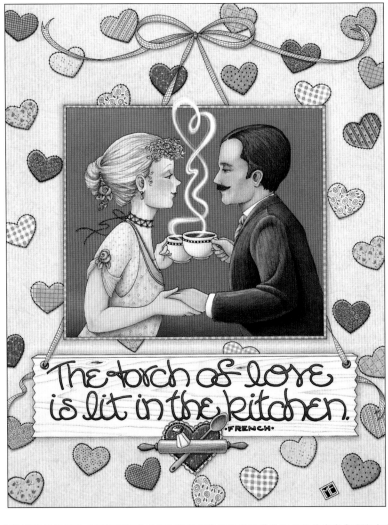

The torch of love
is lit in the kitchen. ·FRENCH·

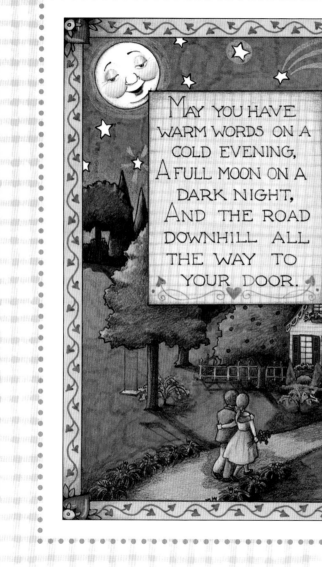

MAY YOU HAVE WARM WORDS ON A COLD EVENING, A FULL MOON ON A DARK NIGHT, AND THE ROAD DOWNHILL ALL THE WAY TO YOUR DOOR.

Learning is weightless,
a treasure you can always carry easily.
—Chinese proverb

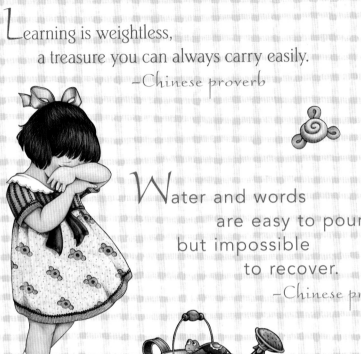

Water and words
are easy to pour
but impossible
to recover.
—Chinese proverb

Not to know is bad . . .
but not to wish to know is worse.
—West African proverb

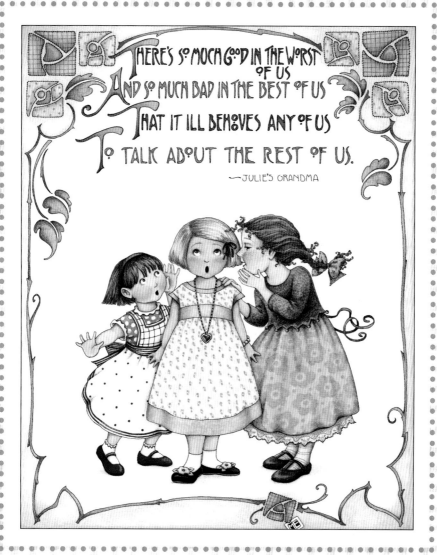

THERE'S SO MUCH GOOD IN THE WORST OF US
AND SO MUCH BAD IN THE BEST OF US
THAT IT ILL BEHOVES ANY OF US
TO TALK ABOUT THE REST OF US.

—JULIE'S GRANDMA

If you don't like something, change it.
If you can't change it,
change the way you think about it!

A journey of a thousand miles
begins with
a single step.
—Chinese proverb

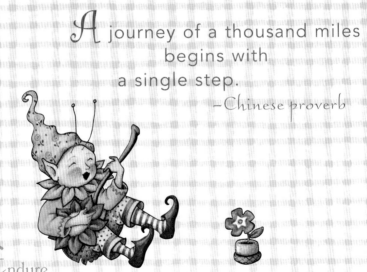

Endure,
and keep yourself for days of happiness.

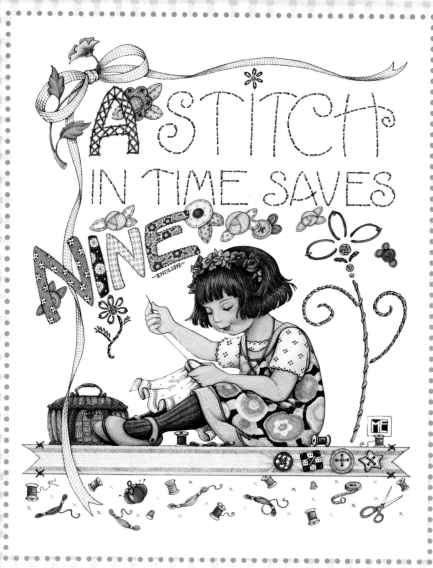

A STITCH IN TIME SAVES NINE

~ENGLISH~

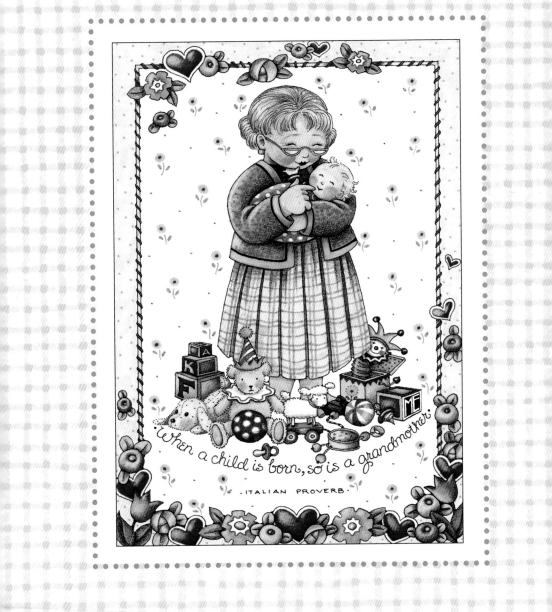

When a child is born, so is a grandmother

· ITALIAN PROVERB ·

Who takes the child by the hand
takes the mother by the heart.
—Danish proverb

Happiness is made to be shared.
—French proverb

The heart that loves
is always young.
—Greek proverb

Kind hearts are the gardens;
kind thoughts are the roots;
kind words are the flowers;
kind deeds are the fruits.

—English proverb

A life without a friend is a life without sun.

—French proverb

Keep company with those
who make you better.

—English saying

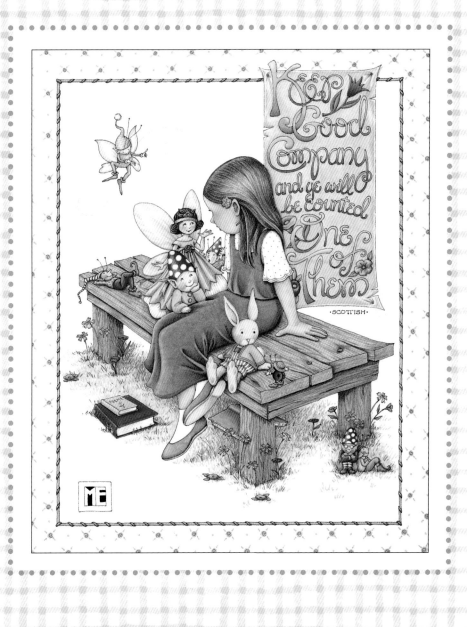

Keep Good Company and ye will be counted One of Them

·SCOTTISH·

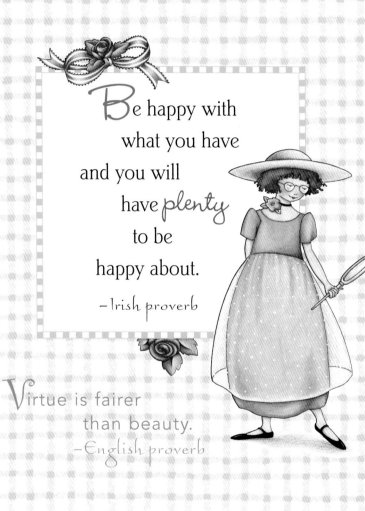

Be happy with
what you have
and you will
have *plenty*
to be
happy about.

—Irish proverb

Virtue is fairer
than beauty.
—English proverb

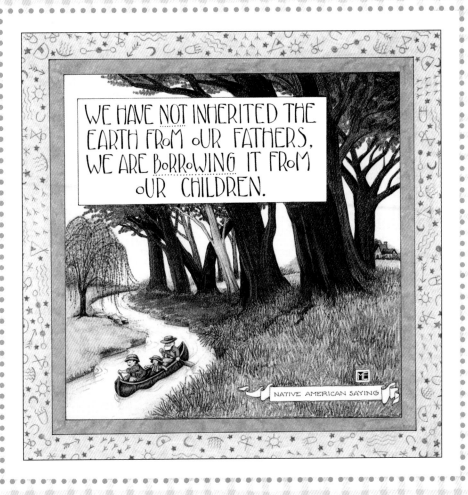

NATIVE AMERICAN SAYING

life has value only when it has something valuable as its object *life...put your heart in* life's too mysterious...don't take it serious! to be happy, don't do whatever you like; like whatever you do *don't let* thing ever be ordinary he greatest p life is doing what people annot do *life* hat you make of it do good, be good or something every mother is a working woman emember, no matter where you go. here you are *a girl's best friend is her mother* th golden opportunity you are seeking s in yourself *it's good to be queen* let go, go o ur first teacher is our own heart *li* if your ship hasn

...from folk wisdom

The heart is the real fountain of youth.
—Mark Twain

It's good
to be queen.

Life...
put your heart in it.

To be happy,
don't do whatever you like;
like whatever you do.

LIFE IS JUST A CHAIR of BOWLIES

If you pray for rain,
be prepared
to deal with some mud.

The only people that never fail
are those who never try.

Life is what you make of it.

Remember,
no matter where you go...
there you are.

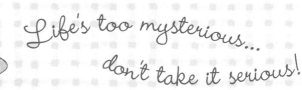

Life's too mysterious...
don't take it serious!

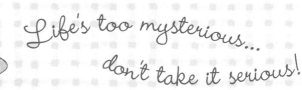

If your ship
hasn't come in—
swim out to it!

The greatest pleasure in life
is doing what people say
you cannot do.

Don't let anything ever be ordinary.

Every mother
is a **working** woman.

This woman
deserves a party.

A girl's best friend
is her mother.

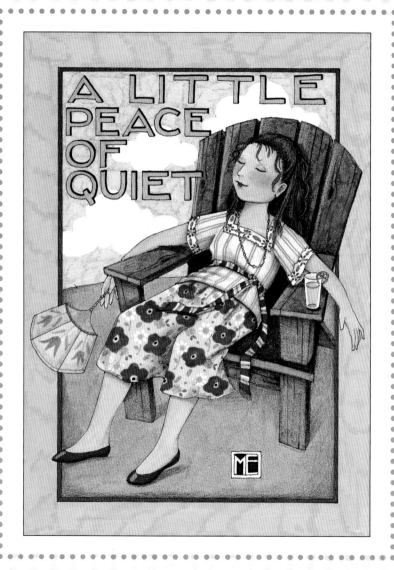

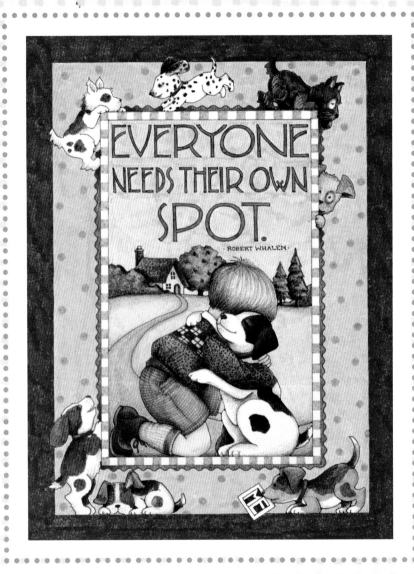

EVERYONE NEEDS THEIR OWN SPOT.

· ROBERT WHALEN ·

The golden opportunity
you are seeking
is in yourself.

Bloom where you're planted.

Worrying does not
empty tomorrow of its troubles,
it empties today of its strength.

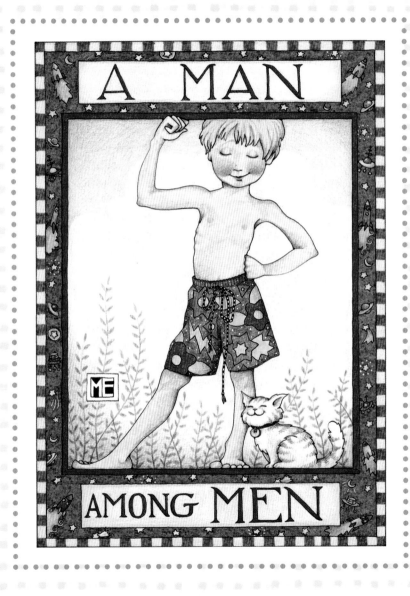

Life has value
only when it has something
valuable as its object.

Don't just be good,
be good
for something.

Little minds
achieve
great things.

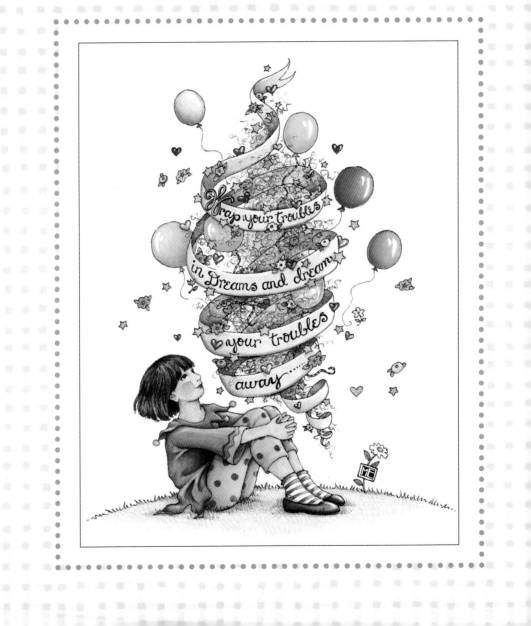

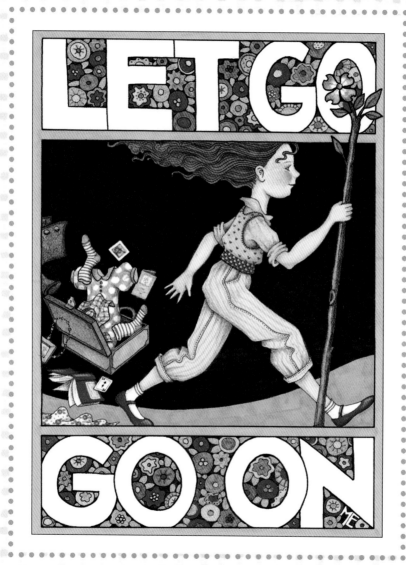

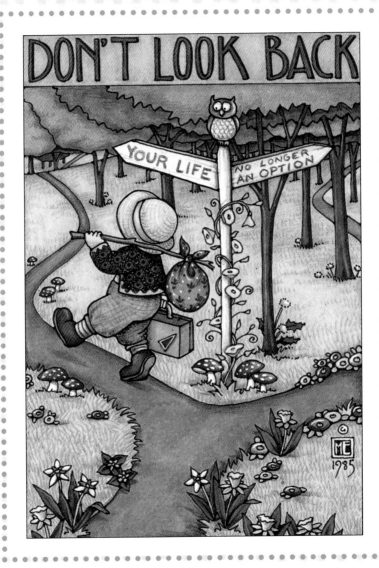

the heart of the giver makes the gift

surpasses a thousand prayers sa'di chil

the day john milton do all things with love

greatest pleasure in life is doing what

has a direction to which he turns; so

disraeli the heart that loves is always your

don't forget to love yourself sören kierkegaard

those who believe in the beauty of their

is life mahatma gandhi the golden opportunit

great things life is both giving and receiving

you better english saying a true friend is the

candle of understanding that shall not

the world henry ward beecher there is nothing li

without a friend is a life without sun

yet to be sweet childish days